NICODEMUS

By Sidney Alexander

NOVELS
Nicodemus
The Hand of Michelangelo
Michelangelo the Florentine
The Celluloid Asylum

BIOGRAPHY
Marc Chagall

HISTORY
Guicciardini's History of Italy
Lions and Foxes

POETRY
The Marine Cemetery:
VARIATION ON VALÉRY
Tightrope in the Dark
Man on the Queue

PLAYS
Salem Story
The Third Great Fool

TRANSLATION
The Berenson Collection
(WITH FRANCES ALEXANDER)

NICODEMUS

The Roman Years of
Michelangelo Buonarroti

1534–1564

Sidney Alexander

Ohio University Press
Athens, Ohio London

Library of Congress Cataloging in Publication Data

Alexander, Sidney, 1912–
 Nicodemus: the Roman years of Michelangelo Buonarroti, 1534–1564.

 1. Michelangelo Buonarroti, 1475–1564—Fiction.
I. Title.
PS3501.L4424N5 1984 813'.52 84-5191
ISBN 0–8214–0778-3

Per
Francesca

perchè mi hai fatto fare
ciò che non osavo fare

VOICES

I

Macellum Corvarium

Old age is a rage. There are those who think that it is serene: the fragile bark of our flesh arriving at that common port, but if the port be peace the voyage is not. No, it is a rage, I tell you, a rage against time which consumes all, a rage against the jaws of that vice, a rage against lost youth, lost loves, lost dreams. For when I last left that ungrateful nest on the Arno for this Babylon on the Tiber—thirty years ago! I still believed I might bring Julius' tomb to an honorable conclusion. Instead—instead—there is, to commemorate my capitulation, that abortion in San Pietro in Vincoli. Saint Peter in Chains! My Moses in chains! Chained to the chariot of incompletion. The undone, the unfulfilled, the unrealized hang ever above my head—this poor head which cannot remember into which drawer I have flung my cap but recalls the very name of the notary who drew up the contract for the Piccolomini Tomb sixty years ago and I remember it because I never did that tomb as I never did Julius' tomb or the twelve Apostles for the Duomo or the fresco for the Palazzo dei Signori or the—but why make a census of all those ghosts? I have always wanted to do more than mortal man can do—carve colossi of mountain peaks—and if I have failed, at least I have failed greatly . . . fallen farther than most men rise. Vanity vanity saith the Preacher. With every hour drawing me closer to the brink, I fear that double death the more; I regret the wastage of my years spent in the carving of stone, in the painting of ceilings. Ahimè! the fables of the world have robbed me of that time given us to contemplate God. A man should carve only his soul . . .

And yet. And yet.

And yet here I am now on the lip of my ninetieth year in this Purgatory puttering about my studio on the street of the Slaughterhouse of Crows (am I the Crow Slaughtered?) and I am still hammering stone though my hand can no longer manage a quill and I cannot even reply to Leonardo's letters. Besides how can I answer letters which I cannot read? That boy writes like an illiterate peasant instead of a Buonarroti. Sometimes, after vainly seeking to decipher his ragged scrawl—track of an unruly mule—the characters begin to swim before my old eyes and I think I am going blind. And so I have torn up more than one of his letters. He infuriates me so, that worthless nephew of mine—last of the Buonarroti—waiting for me to die, rushing down here to Roma every time he hears that I have sneezed. Ah, I will not sneeze up the ghost that easily.

But if I cannot wield a pen I can still wield mallet and chisel. And so I turn my eyes away from Him stretched on the cross and carve Him deposed and He is I and I He but it goes badly, ah badly badly and the rage in my soul is that it goes badly. For, look here, there is too much marble in it, I would carve pure Idea (as Magister Marsilius would have said); instead there is this marble, this substance. Deeper

2

and deeper into the stone I have been traveling and I don't know what I shall find, as the Admiral of the Ocean Sea traveled west to find the Indies and stumbled on a New World instead. Perhaps I too shall stumble on a New World, the pure idea of this Form I want to find and I don't even know if it's there. See that arm hanging in marmoreal space? That is the arm of the Christ I commenced to carve seven years ago (ten? I have lost trace of time) and it still hangs there—an arm without a body—and I leave it there as a reminder, as it were, of what I have left, a concept from which I have departed, a way station. (As when one rides from Fiorenza to Roma changing horses at the inn and next day it is something left: a frosty mountain memory.) I look at that arm and say no! it is too much an arm of this world; and what I want to carve is a body that never was and always is. So I dispense with more and more stone, more and more substance. For seven (or is it twelve?) years now I have been dispensing with substance until now my Christ is a wraith and his mother a shadow.

Still, that arm hangs there. A reminder of what others call the Real.

How can I explain to Messer Tommaso . . . to any of that flock who call me Divino (I divine!), who hang upon my words as if I were one of the Sibyls of my vault—how can I explain to any of them that I want to sing without making sound? carve Idea without employing this calcareous vessel of Idea?

So if I chip off that protuberance——? there. No. *there*!

Last Thursday just when the cartload of twelve marzolino cheeses arrived from Fiorenza (the muleteer cursing in the familiar accents of the Val d'Arno), Messer Tommaso Cavalieri was watching me hammer away at this Christ, his arms crossed in that almost unbearable graceful pose of his, his hip shot like a girl's, and through his beard and grizzled grandfatherly skin (he *is* a grandfather!) it was my old Tommaso, the fair youth who brought me the news of Pope Clement's death and stood in that same insouciant pose watching me as I read the letter from the chamberlain. Thirty years ago! Thirty years ago! And Tomao is still with me, but Clement is not and Pope Paul is not and my faithful Urbino is not and Fra Sebastiano is not and gentle Luigi is not—ah who can call the roll of all those who are not? the world is more densely populated with the dead than with the quick.

Tomao stood there with that loving sarcasm of his gesture and said: "Aò, Maestro, don't you think at your age——?"

They're always telling me about my age. I have been hearing it for three lustres now. Death is my brother.

"What about my age?"

"Well don't you think, Maestro, you exert yourself unduly—— ?"

Unduly! As if all our days were not the life of a flea. The cloud of the Undone hanging over my head.

He stayed a while only, brought me the latest news: the familiar chronicle of Emperor and Pope, the ever-menacing Turks and Lutheran heretics, Catholic Philip of Spain with his foot on the neck of the Most Christian Henry of France,

and Elizabeth—daughter of that other sybaritic Henry of England by his whore Anne Boleyn—lighting more wildfires against the Church now that Catholic Mary was gone, and the new-old complaints of the Florentine exiles who have been exiles so long that homelessness is their homeland.

We went out into the garden later. The sky was pinking like a virgin behind the church of the Madonna of Loreto; the wind soughed Ave Maria in the laurels of the garden. Despite messer Tommaso's protests I had my servant saddle my horse and wrapped in my brown cloak and wearing my broadbrimmed felt hat, I rode with messer Tommaso past the Foro Traiano (whose speaking column is my neighbor) as far as the Banche where the Cavalieri have their palace. It is my wont to ride daily. I do this notwithstanding my eighty-nine years, I have been doing it since I came to Roma, and I still must take my daily ride over the protests of all that tribe of visitors who have trooped through my studio at Macel de' Corvi these three decades—Florentines in passage, Benvenuto Cellini of the exquisite hands and foul mouth, messer Lorenzo Ridolfi and our obdurate ex-Chancellor Donato Giannotti with whom I talked Dante and politics (and who thought to trap me between Brutus-hero and Brutus-traitor), oh so many so many—all those cardinals princes artists from all over Europe, humble artisans, illustrious Romans, messer Annibale Caro (who out-Virgiled the Aeneid with a Noseid and a Cunteid), Berni with no hair on his tongue and the Cardinal-Do -it-all with no hair on his head, lazy Fra Sebastiano with his lute and Ascanio Condivi taking down my words as if he were listening to the Fifth Gospel, oh so many so many and so many gone: Francesco called Urbino my servant whom I loved like a son for twenty-six years and who living kept me alive and dying taught me how to die.

I must send another gift to Cornelia for little Michelangelo. His face pressed against his mother. Skeletons. My first Pietà so elegant and this so rough. From deposition to ascension. Here. A bit off the cheekbone. Yes. Yes.

All of them always concerned about my eccentric ways—don't ride out tonight, Maestro, your old bones, your creaking bones the Roman miasma thieves at the Colosseum Ahi Maestro Michelangiolo there is no need for daily inspection of the fabric of Saint Peter's it will go up without your supervising eye (will it?) Depend on your assistants. Ahi! depend upon that thief Nanni di Baccio Bigio. Name like the rolling of a tambour. When Charles of France came.

They mean well, of course. I am divine. Then why this fuss over my disintegrating flesh? Can *il Divino* suffer from a cold? For ten years now I find it difficult to urinate. I am divine.

Of course the Popes whom I have known here in Roma have never considered me divine. They are on intimate terms with divinity. They know me for what I am. Certainly Paul did from that very first audience. It was shortly after his election. For I had been in Roma only two days, enslaved like one of my own slaves in that ever business of Julius' tomb, when the news came. Pope Clement dead! Back home Duke Alexander was raging in his lusts (my brother Giansimone had

written me all the shameful details of the Duke's attempts at the Strozzi girl and I thought Gian dwelt upon that filth with more than his usual complaisance) and I knew even then that I was not returning to my Fiorenza, for a while at least. And then Paul summoned me to the Apostolic Palace and insisted that I drop all my other projects (I had two tombs in my head: one for the Medici and one for the della Rovere) and devote myself exclusively to him.

"But I am bound, your Holiness."

He regarded me with that air of a ferret. He was only seven years older than I and we had met on more than one occasion when he was the prestigious Cardinal Alessandro Farnese.

"How bound?"

"To complete the tomb of your great predecessor Pope Julius." I thought this might touch his adamantine soul. He had something of Julius' *terribilità* in his nature but it was softened by the graciousness of his sister, the "bella Julia, the bride of Christ" as Pasquino called her, referring to her liaison with Pope Borgia the Bull. Who didn't know?—even I, a neophite in Roma at that time—that Alessandro Farnese had obtained the cardinal's cap through the intercession, hardly spiritual, of his sister?

"I want you to complete the project you have already begun in the Sistine Chapel for Pope Clement—the Last Judgment on the altar wall."

"But I am not a painter, your Holiness."

"Via!" Now he looked more than ever like a ferret, leaning forward and downward at me from the Papal throne, his beard long and white, his finger pointing at me like a pistol. "You are not a painter? Then how is it that you have already covered the end wall with a rough coat of plaster? and screened the wall with boards from floor to ceiling? Are those perchance preparations for a work of sculpture?"

He had me in a trap. I am always in a trap. Life is a gigantic trap. I mopped my brow. At least I had had the foresight to remove my berretta. I have at times forgotten to remove my hat in the presence of these Vicars.

"Pope Clement insisted. But I always hoped—"

"No! Enough of this! It is some thirty years that I have wanted you to enter my service and now that I am Pope, shall I not satisfy this desire?"

"But the tomb of Julius, your Holiness? I am bound. I have been bound like a slave to that tomb for three decades. I fear sometimes that I am preparing my own tomb rather than—"

"Give me the contract that I may tear it up!"

Oh, he looked indeed like Julius now! Suddenly I was flooded with images of my servitude: that furious master of the acorns irrupting into my studio at Santa Caterina to inquire about the progress of the work . . . myself kneeling before imperious Julius at Bologna as he raised a mace against the Cardinal Soderini . . . trembling in the blasts of Julius on the bridge of the Sistine . . . *When will it be*

finished?...When it is finished . . . and threatening to hurl me off the scaffolding which he, seventy years old and gnarled as an olive tree, had climbed hand over hand sixty-eight feet from the floor.

No, I wanted no more of that. Julius rivivus!

"Give me a few days to reflect, your Holiness."

Back at Macel de' Corvi I felt indeed that I was in a slaughterhouse. I thought to flee Roma. As I had more than once fled the thundering Rovere. Perhaps I would go to Genova where Julius' old notary, Francesco Pallavicini, was Bishop of Alaria; and hidden in his Abbey not far from the marble pits of Carrara, I might complete the tomb that cursed my days and nights. Or perhaps I might escape to Urbino where I had long thought of dwelling and where I had already sent my man Francesco Amadori to buy me a house. But on reflection the thought of placing myself within musket shot of the cardinal-killer Francesco Maria, Duke of Urbino, was as unappealing as returning to my own Fiorenza where Duke Alessandro raged and reigned. Ahi! Italy was beset with traps for me, and I was a fox harried by hounds. And I knew, even as I cast over these schemes of escaping Paul, that the days of my physical fleeing were done, that one flees best in the labyrinth of the mind—where no one can follow.

So when I saw him next I replied softly softly to his adjurations and put him off with fencing words. Death might—as death so often does— liberate me. The Holy Father was approaching seventy and I sixty.

Remove the arm entirely? Then where is my Christ? Not here. I want him here. And not here.

While all these hounds were circling me, and I, wary, casting for escape, I had an unexpected visitation. It was in December, month of Visitations. Suddenly there was this new Pope (he had only been elected in October) with eight or ten Cardinals (memory blurs after three decades) in my studio at Macel de' Corvi. Oh, an apparition—the Holy Father himself in ermine, the Cardinals in red—a flock of tropical plumage in my stony haunts—sudden as an apparition. Paul was not the first Pope to visit me; Julius had done the same and that was precisely what worried me. I remember Julius' magical and terrifying appearances from that secret passageway into my studio behind Santa Caterina near Piazza San Pietro, goading me to do his tomb which soon after I knew would more likely be my own. I am used to visiting Popes—the Farnese was the fourth with whom I had had dealings—and since then there have been three more—but when Popes visit me, I am suspicious.

And so I was this day as the lean ferret-like old man, moving with his surprising swiftness and always the bony finger jabbing pointing expostulating—a rapier of a finger—followed by that flock of Cardinals, went about my studio, examining the cartons for the Last Judgement I had already prepared for Pope Clement and the statues for that damned never-to-to-completed tomb of Julius.

It was the Most Reverend Cardinal of Mantua who tipped the balance. He was standing in front of my Moses, mimicking as spectators often do, the attitude of

that captain of the Hebrews. He was an elegant man, the Cardinal; any son of Isabella d'Este was bound to be. But now he seemed stern, judgemental, even fierce; in unwitting mimicry he was trying to infiltrate the bejeweled fingers of his right hand in his sparse beard as my captain combs his fingers in that flowing beard which for me was the flowing of all Time. So he stood there, a suspended moment, and turned to me, with an expression of bemused, even dazed admiration.

"Maestro, this statue alone is enough to do honor to the tomb of Pope Julius."

It was useless to remonstrate that this was only one of forty, that my dreams are always outsized, that life is a cutting down. I must have had a premonition of the miscarriage of my dream, the abortion that offends me every time I enter Saint Peter in Chains. But if I had a flash of the future, it vanished at once. For the Pope had entered the fray now; he was mounted and charging at me, destoying the last vestiges of my resistance.

"Enough of all this talk about your contract. You need not fear the threats of the Duke of Urbino. I will see to it that he shall be satisfied with these statues by your hand, and that the remaining three shall be assigned to others to do."

The Cardinal, I say, had precipitated it all. I remembered (as I remember now my remembrance. So time is an enfolding within a folding, a maze from which no Dedaelus can escape) another Cardinal who had sought to be my intercessor with another Pope. Poor Soderini! Julius' chianti-red face and that mace quivering over the Cardinal's head and he pushed out of the chamber by the papal guards.

But now, another Cardinal had said exactly what another Pope wanted to hear. And so when that gorgeous company of prelates had departed from my studio, I knew I had no choice. I was to serve Paul for fifteen years.

The Holy Father was as good as his word. He intervened with the Duke and so I was freed of one slavery to enter upon another. I suppose Francesco Maria was in no position then to clash with the Farnese; he had already incurred his disfavor over the marriage of his son. But I was surprised nevertheless. I feared the Duke. I feared his threats, he or his agents calling me thief and insinuating that although I was pledged to complete the tomb of his uncle, I had taken that money under false pretenses and was using the ducats for—who knows?—other purposes— mayhaps to keep a harem of courtesans (as the Duke himself would have done). So I was surprised that the Duke yielded so readily to the Holy Father's suasion. For this was the very Francesco Maria who had stabbed the Cardinal Alidosi to death in the streets of Ravenna. I was painting the vault then and the tide of that blood washed back to the Apostolic Palace and the Pope weeping publicly over the death of his favorite and cursing his nephew, the murderer, with the oaths of Genovese bargemen. I know those oaths very well. I have heard them too often at the Marina of Carrara, waiting for my marbles to be shipped to the Urbs.

Thus by late Spring, I was back in the chapel, preparing to complete upon the altar wall what I had commenced upon the vault—now it was the end of the world as then it had been the beginning. The beginning and the end. Alpha and omega. Despie my disinclination for the task I was seized with it. I hate to paint; it is not really my profession. But once I am engaged in it, I know no other way out of my despair than to paint my way out. I was back in the familiar chapel, in the familiar labyrinth, doing that which I did not want to do. Vorrei voler signor quel ch'io non voglio. I was being moved again by a Yes and No.

I was back in the Sistine Chapel and it was all so familiar . . . and so remote. Those luminous forms floating upon the barrel vault, when had I set them there?—a quarter of a century ago! a quarter of a century ago? I looked upon my Adam languid as a woman awaiting the stiff fertilizing finger of God; my Eve rising to creation in a posture of prayer, grateful and humble and clumpish yet as the earth; and that other Eve, pensive and beautiful, whose limbs echo the coil of the serpent; and that other Adam, more savage that the painted savages the Spaniards have been bringing back from the New World; and my Noah, naked as a rivergod beneath the wooden winecask and Ham and Shem and Japheth embarrassed at their father's nakedness, they all the while naked as himself; and my God (my God!) swirling over the altar separating light from darkness in the swirl of stars and clouds that must have been the First Day. I looked upon all this and I saw that it was good and I was proud that I had done it, so proud that I felt I was committing the sin of pride, for how many Popes had been created under my ceiling?—wily learnèd Leo and the Flemish schoolmaster Adrian and unfortunate Clement and now Paul who combines the nepotism of Borgia with the energy of Julius, the humanism of Leo with the zeal of Adrian.

Ever since Leo, they were all in a sense born under my ceiling as those figures above—my painted heaven—had been born of my brain and my brush.

I was proud, I say. It was not that I was revisiting unfamiliar precincts. I had been in the chapel many times since that long-ago day when I had set down those forms. I had been in my thirties then and now I was in my sixties (and now I am on the verge of my nineties!) and I looked upon it all differently than I had looked upon it on the many intervening occasions. All those years—when I came with one Papal Chamberlain after another, perchance to see how the colors were holding, perchance to play the cicerone for some visiting Florentine,—the forms spoke to me, as it were, from a state of stasis: they were what they were, as I had fixed them there; and they would remain (so long as paint remained) as they were, in the gestures I had set them. I had made my Creation and there it was. The very fixity of it all—despite the changing lights of morning or noon— removed it from me, don't you see? I felt I had fathered forth children that were no longer mine. They no longer interested me; their life was their own. I was not even amused at the game of acorns and genitals I had played against the House of Della Rovere. I

didn't react. That world, sixty-eight feet above my head, was more remote to me than Cathay.

But now, faced with the task of decorating the altar wall, I could no longer be indifferent. The very serenity of those figures—more than three hundred and fifty of them!—floating in a sweet rainbowed light— was an echo of a world I had left, like the shore of Versilia seen mistily from a barge, it was the light of my youth and I had departed from it and I could never return to it. It had become, in a way, my enemy. I had to look away from it, cast my eyes downward (besides my neck had developed the old crick of those years after the Sistine when I couldn't even read one of Buonarroto's letters without holding the letter above my head) and I turned my gaze to the virginal altar wall, already prepared with the first rough coat.

How frail is friendship! I almost lost the friendship of that delightful gossip Fra Sebastiano over the intonaco for the Last Judgement.

Fra Sebastiano was a Venetian and a painter. And I am Florentine and a sculptor. And so our friendship flourished best in the loamy soil of distance; he was my ear in the Curia; my condottiere, self-appointed, in a war I had never declared; he fought, he said, for me against Raffaello and his synagogue though I cared nothing at all about fighting Raffaello. It was obvious that everything he knew about art he had learned from me. Even a blind man could see where the naked athletes of his *Fire in the Borgo* came from; he who previous to the exposure of my ceiling had painted in the arid sentimental manner of his master Perugino.

I had no need of Sebastiano's sword. What motivated him really was jealousy of Raffaello, a jealousy so fierce that even after the Urbinite's death, the lazy friar, who had practically ceased working once he was appointed Keeper of the Seals, thought to reclaim his primacy by painting most of my Last Judgement for me since he knew I didn't really want to do it. Like most Venetians he couldn't draw, and I cared little about color. After all, I had provided him more than once with designs for him to color, and he must have imagined that this business of the Last Judgement would turn out similarly in the end, he softening the substance of my forms with the accidents of his color, as if the harsh mountains of my Mugello were incongruously bathed in the golden light of his lagoons.

I might have chuckled the whole thing off—who could take sweet-singing Sebastiano Luciano seriously? For the tingling tickling of his lute, his kite-soaring tenor voice, I had always been disposed to take joy in his comradeship. But when I saw what he had done now without my leave, prepared the altar wall for painting in the medium he liked best—oil paint— even on a plaster ground; then I had no choice but to tear the whole thing down and for a while it meant the tearing of our friendship as well. Oh I am unfortunate in my assistants! It was 1508 all over again and the Florentine brigade, whom I had summoned to help me with the vault, locked out of the chapel and Francesco Granacci's plaintive voice murmuring Maestro! Maestro! against the blows of my hammer as I destroyed what they had

done. I am doomed to work alone. I have never found anyone who thinks as I do. Not even Messer Tomao.

So I had the wall prepared anew: rebuilding it with new-baked bricks against the damp and slanting it eleven thumbs from the top so that no dust could gather, and I spent my days developing the cartoons I had already sketched out during the pontificate of Clement. It was a torrid summer in Roma, the Tiber the merest trickle, but there was a great flowing of papal agents to and from Macel de'Corvi. My man Urbino lamented: "Aoh, Maestro, all these horses to stall, and these proud prelates to feed. I must have more money. You can't feed them as you feed yourself—on crusts and herring."

"I have always lived simply."

"Poorly, say I. Poorly, Maestro, much more poorly than is your means."

"My means are mine to determine. I have two brothers in Fiorenza who would be nothing in the world without my support, though they don't deserve it, and a worthless nephew and a niece to marry off, farms in Settignano and Pozzolatico, a house on the Via Ghibellina. Expenses expenses . . ."

Urbino twisted his mouth up in that attractive grimace that always wins me over. He had only been with me then for six years but from the very beginning I knew that at last I had found the perfect man for my needs. He came from Castel Durante in Urbino and had the grace of a Madonna by his countryman Raffaello although he was stocky, his eyes the color of pietra serena. Shorter than I, he worked like a mule, disappearing now and again to "dance on velvet feet" which meant an encounter with some courtesan of the candle behind the Colosseum, and I did not begrudge him this so long as he did not get infected with the *morbus gallicus*. After more than twenty years in my service, he took unto himself a wife, such a wife as I myself might have chosen were I not wedded irrevocably to my art. I loved Cornelia, I loved her for her grace, her humor, her poetry. I love her even more now that poor Urbino is gone to a better life and has left me here in this cold studio with no one I can trust: my women servants are all bawds and the men bullies and thieves. My man Pier Luigi Gaeta was arrested for stealing antiquities and even I—the divine Michelangiolo—summoned before the magistrate like any common thief and I, the greatest maker of Prisoners, risking to be placed in an actual prison were it not for the intervention of some Cardinals.

Well, that has been my fate with servants, always with the exception of my belovèd Urbino. And since he is gone, I have had to make do with Antonio who cannot even wait for me to be out of the studio before he is at it like a goat with the cook, sometimes on the pallet right under the eyes of my Nicodemus! Which is to say, right under my very own eyes.

Then in September came a brief from the Holy Father. I have always kept that brief. I take a sculpturesque delight in Latin documents. It doesn't matter that I never learned to read the Latin of Cicero; I can manage well enough with curial Latin. The letters are incised in my memory. For this was my first appointment as

supreme architect and painter and sculptor of the Vatican palace and Paul addressed me as his Beloved Son "Dilecte Fili . . ." praising my "Excellentia virtutis" in all the arts, and appointing me a member of his household with a pension of 1200 golden ducats raised upon the revenue from a ferry across the river Po, at Piacenza. "Passum padi prope Placentium," all those P's like a passage in the Mass but the revenue proved to be unremunerative nevertheless and had to be exchanged later for an office as Civil Notary in the Chancellery of Rimini.

So I became a painter and a tollkeeper thundering a final judgment as I counted my coins.

Now the first thing I had to do was to destroy three frescoes by Perugino and two of my own on the altar wall to make way for my new scheme. I was not unhappy to blot out those abominations by Master Vannucci of Perugia. I have never been able to abide his mincing Madonnas, his saints dancing cataleptically with eyeballs rolled to heaven. Oh I will admit that his light is beautiful and his trees wispy-golden against distant horizons but that does not excuse the posed swayingness of his figures, the unimaginative symmetry of his compositions. Nor was I unhappy to blot out my own lunettes as well. If for this new voyage I had to jettison some baggage of the past, I was prepared to do so.

For it was a new voyage, you see, and though I had been loath to embark, now that I had weighed anchor and was really under way, now that the helm was in my hand and I was captain and crew, I was eager to discover the new world that is always a new work. For though my hand may obey my intellect, and though I always plan meticulously before setting forth, always there are surprises, the greatest joy are always the surprises, the unforeseen, the figures that grow ex nihil right under one's hand, the heads, thighs, soft flow of limb and belly that seem to pour out of my brush as if they had a life of their own.

I really had commenced that Judgement almost half a century before. For once I had sketched out my plan it seemed to resonate like the sympathetic strings of a lute, it was a memory in my head, a memory of Greek words and a hooknosed tutor and horses that were not horses and men that were not men. The Battle of the Centaurs! Yes, the Centauromachy that Messer Poliziano had suggested to me when I was a boy in the house of the Magnificent on the Via Larga. There was the seedbed of my Judgement! the central centaur with his arm raised became my judgemental Christ, my Moses-Christ, my Christ with the face of an Apollo and the body of a Hercules; and in the lower left hand corner of the Centauramachy I recalled a figure of despair in profile to the agitated field of those squirming bodies and now I turned him forward and he became one of the damned dragged down to Hell by a demon. Image begets image, form begets form, I never forget any form I have once set down or seen; my skull is a reservoir of thousands of bodies in every possible position, I am inhabited by my memories, and sometimes the pressure is so great that I feel my head is about to burst, as the banks of the Arno burst when the river swells with the spring floods of melted snow. Perhaps that is the reason for

these headaches that have plagued me all my life, this burning boring drilling right between my eyes so that incised forever on my forehead are seven lines of pain like Dante's seven circles of hell.

And just as the Centauromachy was a swirl of figures contained in too small a space (like the figures in my head) so was this Judgement as I planned it that summer. Every day the figures multiplied as they had multiplied on the vault; one would say they were copulating in my mind, they obsessed me and cried to be born.

But withal I was happy. I am always happy when I work although my happiness takes the strange form of moans and lamentations. But these are the strivings of a lover. Pain and ecstacy are close allied.

Amidst my preparations for my Judgement, the Holy Father issued his Bull of convocation for a council to reform the Church in its head and in its members. Like most saints Paul had been a sinner first. He had had two mistresses and four illegitimate children whose fortunes he sought to further in every way. Only after he had been Cardinal for twenty-six years was he ordained priest; but everyone said that once he had been ordained he led an exemplary life. I don't know. He never exploded in my face as had Vesuvian Julius but yet I felt that the explosion was there, in his canny eyes, in his hunched lean form. Certainly he was not—despite his shared nepotism and erstwhile sensuality—like the Borgia who had created him. Cultured as Leo, he spoke as elegant an Italian and Latin, and he was certainly a friend of us artists—no one could deny his humanistic attainments. But the deep core of Paul was hidden. I never knew how to behave in the presence of this pope. He spoke slowly and so softly, almost whispering, that one had to lean close to hear his words and everything he said was so beshrouded in mist that the shape of his meanings could hardly be discerned. Obviously while the Holy Father sought to enchain those to whom he spoke, he for his own part wished to remain free, uncommitted to the last. Thus while all the world had already yielded or was preparing to yield to the Emperor, the Farnese, shifty as Clement but more skillful in his maneuvering, maintained precarious neutrality between French Francis I, reluctant to accept defeat, and the greatest conquerer since Charlemagne, Flemish-German-Spanish Charles V; and all the while there was I in the Sistine swinging my own precarious balance.

Now and again, through my friends in the curia, I heard news of the council the Pope was preparing. It was said that the Lutheran heretics of Germany who now call themselves Protestants, were being invited to the council, that it might truly be ecumenical and heal the schism in the Church. It was said that Paul's zeal was beginning to frighten some of the more mundane Princes of the Church who saw that the Pontiff was more than inclined to re-examine everyone's account. He even forbade his own grandsons—sons of Pier Luigi—whom he had newly created cardinals at fourteen, to participate in the carnival, an austerity which those hotblooded adolescents found rather difficult to accept.

In August, when I was directing the carpenters in the construction of a

scaffolding against the altar wall, came the news of Charles' conquest of Tunisia, and the Holy Father, for all his distrust of the Emperor, rejoiced at this victory for christian arms, and participated with all his cardinals in person at a solemn mass of gratitude. In the Curia, my gossips whispered, the hope was that Charles would proceed to the conquest of Constantinople, and thus the breach in Christendom would be healed, proud Francis would join the new Caesar, and the Pope himself would aid with money for the construction of a great naval armada to sail on a new crusade to redeem the Holy Land from the Turks.

That was the talk those days—council and crusade—and I could not—for all the hammering in the chapel, for all the shouting and profanities of my workmen (a sound which pleases me, I must admit, a sound as true as the ttchhpp tchpp tctchpp of scarpellini at Carrara), the slopping churn of plaster being stirred in the great copper vats, I could not fail but to hear that political talk. All my life I have sought to wall myself away from it, and in the hot moments of creation, I do succeed: intent upon the pursuit of painted or sculptured form, what care I for Popes or Emperors, or Christians or Turks for that matter? But when that hot moment has passed, the world pours in on me—fathers in the flesh and Holy Fathers, brothers and fraters—I have no end of troubles.

The world certainly poured in on us that April day of 1536 when the Emperor came to Roma.

Rumor had it that the Pope, suspicious of so much grandeur, had first decided to go to Perugia, but changing his mind, assembled three thousand infantrymen for his guard and remained in the Holy City to greet him who was at once Most Catholic King and Holy Roman Emperor.

The corteo was headed by four thousand Imperial infantrymen, filed six abreast, and five hundred Horse, followed by the envoys of Fiorenza, Ferrara and Venezia, Roman barons and grandees of Spain, finally the Senator and the Governor of the City. Immediately preceding the Emperor were fifty young Roman nobles clad in violet silk.

By contrast with such blazing splendor of Roman and Spanish nobility, the simplicity of Charles V was all the more striking. That monarch upon whose realm the sun never set, glorious conqueror of the unfaithful whose recent victories in Africa were proclaimed in resounding inscriptions on every hastily-erected arch of triumph through which he rode, wore not a single sign of his dignity, no ornaments whatever. Simply dressed in violet velvet with a beret of the same color, he rode a white charger, between the Cardinals Cupis and San-severino, and flanked by the Conservators of the Urbs in ancient costumes, explaining to their most eminent guest the ancient ruins by and through which the parade was passing. The Imperial party had entered from San Paolo outside

the Walls and through the Gate of San Sebastiano, newly stuccoed and frescoed in his honor, then marched by the Terme of Caracalla and through the Arch of Constantine to the Colosseum, where the Emperor stopped to marvel at that carious splendor. Then he remounted and rode through the Arch of Titus and all through the Forum up to the Arch of Septimo Severus.

There it was that the small party gathered at my studio caught their first glimpse of the cortege. For, turning at the Arch to proceed to the Piazza di San Marco, all that glorious panoply passed right by my studio. So that I saw him clearly for the first time, he who was Lord of the World for our century, master of the world's game as Julius had wanted to be but never was. And it was surprising to us all—even to Messer Donato Giannotti who was not innocent of greatness, and to my servant Urbino, like all simple men disposed to be impressed by the skin of things—and to Messer Tomao, who though a Roman nobleman preferred to witness this event in my company rather than play the official part in the ceremonies that he was entitled to—all of us were surprised, I say, to see how unimpressive this new Charlemagne was—a skinny man with a beard more scraggly than mine, sitting his white barbary charger well (he lived more in the saddle than on his feet, this emperor) but yet withal a rather insignificant figure simply dressed in violet velvet with a beret of the same color, riding between several cardinals and the conservators of Roma who were explaining the ruins to him (including my own private ruin, the column of Trajan across from my house)—all the conservators rigged up in costumes of antiquity as if by draping themselves in togas they could assume the ancient power when the truth was that Charles was the true Roman, not they. And this is the curse of our Italy, we are the schoolmasters of the world but subject to our pupils. All Europe comes to learn from us how to paint or carve, but they learn with their heel upon our necks. That day of Charles' coming the Urbs was plastered with pomposity, and it must be said that the simplicity of his bearing shone all the more against the fustian of its setting.

So then the cortege passed my studio and I thought, seeing the Emperor of the World, on his way to see the Holy Father in Saint Peter's, that on the ultimate day, Charles would count no more in the balance of the centuries than my servant Urbino, and that in the Judgement I was then painting I could—if I would—the thought flashed swiftly, with a sort of grin—I could include him among the damned if I but chose to do so. In *that* world, I was God, I created the saved and the damned (as I had already created the first days of creation of the vault) and painting the Judgement I judged. Oh, that was the terrible pride I possessed thirty years ago, and sometimes even in this dark night of terror that precedes the dawn of my death, even now, my body tottering, my sight dimming, my hand quaking, I know at times resurgences of that pride. When the hammer rings like a great bell on the stone, and chunks of marble big as my fist fly, and the shape first in my mind begins to emerge from the stone—ah then I know the surge of that pride that

has sustained me all my life, that made me reputed to be *un uomo terribile*, a terrible man, the terrible man who made Pope Leo weep ("That man is impossible to get along with", according to Sebastian's letter) tears in the eye of Lorenzo's smooth son, tears that I would not yield girl-like to his bidding as Raffaello did), pride that has been my sword, my shield, my fortress against a world, fortifications behind which I could (and still can) hide. That is my pride and I know my Creator knows that this is not truly pride, this is not the sin of pride, but fear enmasked, the courage of terror.

From my brother Giovansimone who came to visit me that summer I learned that Charles' reception in Fiorenza (whither he went after four days in Roma) had been even more spectacular.

". . . from the Certosa through the gate of San Pier Gattolini in the evening at the twenty-second hour and all the clergy waiting at the gate to lead him in procession to Santa Maria del Fiore. And the magistrates waiting on him there in the cathedral, kneeling at his feet as if he were Jesus Christ him—"

"Mind your blasphemy."

"—self (Gian's voice flowing on languidly as a viol) and forty young nobles all dressed in purple satins with white stockings and swords and daggers chased with silver and purple velvet scabbards and similarly the berrettas embroidered in gold thread with a white feather—"

"Vestments vestments! Does the meaning of a man reside in his clothes? Truth lies in the body, the naked body . . ."

"—on the left side because that was the livery of the Emperor. And over Caesar's head a rich baldacchino of brocade . . ."

He went on like that, irritating me as always by his urbanity. A man who takes fire easily cannot abide the cool calm of another, especially if that other happens to be one's brother. Gian's complaisant uncombustibility always manages (oh but he is gone too!) *managed* to set me aflame.

As when he set fire to our farm at Settignano out of spite toward our father, lifting his fist against the old man, and the furious letter I wrote him then, threatening to teach him how to behave according to the book of Leviticus which prescribes stoning for such an offense. In the third year of the Sistine, my beard to heaven, that I should have had to be wrenched from my Adam, the Adam I was creating—*I was creating*—to reprove the unfilial obscenities of a brother!

—All my life.

"—and every day a festa." The kneeling, the triumphal arches put up for the occasion (made of papier mache!) A week of ceremonies, white horses, gold chains, the city adorned with the double-headed imperial eagle and suitable slogans. His Spanish guard murderously grim and black in the sunshine of the

Piazza Signoria, glinting with halberds, and by the Emeror's side, messer Francesco Guicciardini very official in a smooth lucca of purple velvet.

"How long did Charles stay?"

"Until the fourth of May. I don't think he was much pleased with us despite all of Duke Alessandro's efforts."

"But isn't the Duke marrying the Emperor's daughter?"

Gian was unusually reflective. "It is odd. One would assume that this marriage of bastards would signify some sort of alliance. But then how explain that the Emperor left Fiorenza with no imperial favor bestowed whatever? No privileges, no memories, no signs whatever that he had even been there. Nothing. Despite all the pomp, all the banners hung out from the palace windows, the torches, the speeches, and all the open marks of favor from the Duke who depends on the Emperor's support against the exiles . . ."

It was indeed hard to understand. But all the political gyrations of those days were, if not beyond my comprehension, an alien realm from which I sought ever to absent myself. How could I, a Florentine, steer a course between Pope Paul who detested both Medici Dukes—ill-fated Alessandro, and his successor, Cosimo I—because they leaned upon Spanish muskets, and the Florentine exiles who were my close friends in Roma and had attempted in vain to swing the Emperor's support toward them? (but that had shipwrecked entirely, and now the Emperor was in the Moor's bed or the Moor in the Emperor's bed, since Alessandro had married Charles' bastard, Margherita of Austria.) How reconcile the Cardinal Ippolito's support of the anti-Medici exiles when the Cardinal was himself a Medici? Or was it that his detestation of his cousin the Moor Alessandro was even stronger than his loyalty to the House of Medici?

At any rate the Cardinal Ippolito's role in the game was swiftly resolved when he unexpectedly died of a fever at Itri. I was just then setting down my angels in the vacant lunettes that resulted after blotting out Perugino's frescoes. Most likely the Cardinal was poisoned, perhaps at the behest of Alessandro. Perhaps at someone else's behest.

The Holy Father certainly had good grounds for hating the House of Medici. Had not the last Medici Pope, Clement, robbed him—as he was not at all reluctant to say—of ten years of the pontificate?

And now the Medici—notwithstanding that unfortunate Piero's daughter Catherine was married to the son of the Christianissimo King of France, notwithstanding that the Magnificent's son had been married to a French princess, notwithstanding our city's traditional friendship with the French—cleave the giglio and you find the fleur-de-lis—were as subject to the Emperor as the barbarians in Peru. The world entire was his empery. Gold flowed to him from the mines of the New World. French Francis humiliated and beaten, bided his time and we all knew that the perpetual war between King and Emperor was bound to break out again at any moment; the Turk despite his defeat in Africa breathed his

dragon's breath against Budapest where Charles' brother sought to ward off sagacious Suleiman the Magnificent; Henry of England was preparing to behead his new bedmate Anne because she was granting her favors too freely (even to her brother! it was rumored) in a desperate effort to present her liege lord with a male heir; and Fiorenza, my Fiorenza, casting anxious eyes in every direction like a stag at bay, allying itself with the Emperor but seeking not to alienate the Pope, the while Paul in his turn gave all the world lessons in the art of blowing hot and cold with a single breath, how to be ally of Emperor and King and neutral all the while, how to be committed to neither and to both, how to pursue a policy of dolphin and crocodile—swiftest and slowest of all animals.

All these political maneuvers, I—who hated politics and maneuvered happily only in my art—I learned from my friends, the Florentine exiles in Roma. Especially from messer Donato Giannotti, former Chancellor of the Republic, and as steeped in politics as I am in my art. He was especially intrigued by the skill of Pope Paul III. Like all great Lords, the Holy Father was a master of diplomacy by way of the bed. So he sought to ingratiate himself with the Emperor and the French by marrying off his grandson Ottaviano to the Emperor's daughter (after she had been widowed of the Moor) and his daughter Vittoria to the Duke of Vendôme. But notwithstanding the Pope's skillful maneuvers to strike a balance, there was no balance. Charles was master of all Europe. Roma and Venezia swarmed with exiles—Milanese, Genovese, Napolitani, Fiorentini—there they were, stewing in their own juices, quarrelling, plotting, hoping. Sometimes to suit his purposes the Pope made temporary alliances with these exiles against the Emperor. But such alliances never lasted long. We lived under the beaks of the Double Eagle. And everywhere the Ghibellines were victorious.

In the midst of all this I was painting my Judgement. On that scaffold, facing the virgin wall, staining it with my designs, my dreams, day after day in that huge chapel, hot in summer and freezing in winter, under the vault of my painted dreams of a quarter of a century before, I warded off the world. The chapel was my shield.

No, I had no desire to return home to my own country. My father was dead, my favorite brother Buonarroto was dead, and my city was under the savage domination of that monster Duke Alessandro. Even in the den that was Roma, even here at the center of the whirlpool, I shuddered to think of the claws of the Duke. I meant to stay out of his reach. For he had hated me ever since I refused to build the fortress he wanted erected as his bulwark in the heart of Fiorenza against the Fiorentini. No, I would not be part of that. I had no instructions (I told him) from Pope Clement. Luckily I was in Roma when Clement died. I dread to think what might have happened to me had I been in Fiorenza at the time.

All this in my head swirling like the saved and the damned. Days of Vittoria Colonna and Tommaso de' Cavalieri, of the Column and the Knight, of my two loves, Greek and Christian, forbidden both in their several ways.

Everyone in Roma knew that during his brief stay the Emperor of the World had found time to pay a formal visit to Vittoria Colonna, the Marchesa of Pescara. No one was surprised. He was more beholden to her—or to the memory of her late husband who had been his general in the Italian wars and whom he had intended to place upon the throne of Naples—than to the Holy Father. She was, you might say, the Holy Mother. More than that she was the queen of letters when I arrived in Roma at the beginning of Paul's pontificate. I longed to know her and when at last I did, she became one of the two suns that illuminated my peculiar heaven. Vittoria and Tommaso. My Pope and my Emperor. All the dark years of the Judgment brightened by those two luminaries.

When did I first meet Vittoria? I try to remember. But I am too old now. And she is long gone. Ten years of our love. Kissing her cold hand as she lay on the bier. Not even her cold brow did I dare. Her warm lips I never kissed. We seldom even shook hands. I bowed, she nodded. For there was something forbidding about Vittoria. She was too great a lady, in her late forties when we met and I in my sixites, I remote in the making of my Judgement and she remote in her piety, her widowdom, her misplaced loyalty wasted upon an object unworthy of it: her late husband, the treacherous Marchese Francesco d' Avalos (though no one ever dared in Vittoria's presence breathe a word of his treachery) so that she lived in a state of benign ignorance of her ex-husband's true character like those simple folk who make a shrine of a thief and by and by their faith transforms, as in an alchemist's alembic, the thief into a saint.

So it was with Vittoria. Her husband's betrayal of Italy was one of the subjects we never discussed. She had carried that image with her from Ischia to Roma, from convent to convent where she lived like a nun though she had never taken vows. We used to meet often at San Silvestro in Capite, on the Quirinale hill not far from my studio, and we talked of oh many things: of art (while she listened) and of Valdes' ideas of redemption by the blood of Christ alone (while I listened). She was always surrounded those days by a flock of cardinals and prelates—the great English Cardinal Reginald Pole with a huge black beard depending to his chest and an elegance of manner that revealed his royal blood, related as he was to the Kings of his isle, and a sword-flashing master of Italian, though the edge was somewhat nicked with an Anglosaxon "r"; and the Cardinal Contarini, a master diplomat as are so many of those Venetians, but who seemed always to bear on his florid face the surprise he had first felt when news of his elevation to the Sacred College had arrived during a session of the Venetian Senate, he not even a deacon of the Church; and Bernardino Occhino, General of the Capuchins, whose vehemence in discourse should have forewarned us all that he was fated to join the Lutheran heretics as indeed he did.

What drew us all together—ill-assorted as we were—was our common convic-

tion of the need for a reform in the Church. Not that any of us—not even Occhino at that time—thought to break with Mother Church as Brother Martin had done, dragging half of Europe with him. But all of us knew that the flame lighted in Germany would not have ranged so far and so fast were not the fuel laid, dry and propitious for the burning. The fuel had been laid for a long time, the corruptions were there even under this new Pope seemingly so zealous for reform, All his zeal did not prevent him from appointing his buggering son Pier Luigi as gonfalon of the Church; and from promoting the fortunes of the Farnese as ardently as Alexander had promoted the Borgia. The times had changed somewhat since first I came to Roma but beneath Madonna's Robes there was still Bacchus' belly.

So we had cause enough—those of us in Vittoria's circle—for reform. But we were no Germans any of us; we refused to draw the bowstring tight; our logic went so far and no farther. Those days I read often from the little book of sermons of Fra Girolamo I have always carried about with me, drawing images there for my altar wall, the damned with white teeth flashing in the inferno, the blessèd drawn upward by angels (without wings and naked as boys I have seen bathing in the Arno and with their male stalks dangling even as their souls rise to heaven).

But in this skeleton of a Christ, there is no stalk at all. No flesh. No agitations of the flesh. The state to which I have arrived after eight decades. I can scarcely pass water through mine. Ultimately we come to spirit, volente nolente. Would Vittoria have liked this Deposition? The many drawings I gave her—a Crucifix, a Pietà (not unlike this Pietà if my blind eyes and blind brain remember rightly) a Samaritan woman at the well.

How unlike the drawings I was making at that very time for messer Tommaso! For every Christ a Ganymede, for every Madonna a Tityos. Oh he was beautiful of form as Vittoria was not, his voice suave and brownsounding as a viol, his neck and throat reminding me ever of the roots of an olive tree half emerged from the warm earth and the trunk (his neck) rising there. His eyes olives. Black. His smile ravishing me entirely so that I, an old man (not as old as now but old enough) past all that, wrote humble (no, humiliating) letters to this boy whose beauty had bereft me out of my senses. Oh, it was terrible and wonderful. Seizing every excuse to run to Roma before I crossed my Rubicon forever.

There was I, then, in the first years of the Judgement swinging between Bacchus and Madonna as I had swung in that faraway time of my youth when first I came to Roma and carved the drunken god for messer Gallo and the ivory Lady for the Cardinal of Saint Denys. She is still there in the French Chapel with my name carved boldly across her bosom and Gallo's god still riots in his garden. So art outlives its maker for soon I shall be gone while they—marble children of my mind—remain forever. Bacchus and Madonna, the two poles of my spirit between whom I am stretched forever like a prisoner on a rack.

They met but rarely, my Bacchus and my Madonna. I frequented them as if they were two chambers far removed from each other in the mansions of my soul. She was plain and I loved her for her soul. He was beautiful and I loved him for his

beauty. None of this knew Vittoria where the talk was all of Christ's blood, not Tommaso's.

And to think that now thirty years later, he comes to bring me sweetmeats and wine, or to hold my horse which I persist in riding every day (whenever the weather and my old bones permit) to supervise those thieves at work at the basilica, he, my own messer Tomao signor mio carissimo, grizzled now almost like myself, bearded, a grandfather; and for him those green days of our first friendship are far away now as when one looks down the long nave of new Saint Peter's toward the altar. But even then, he never knew, young Cavaliere, the ardor I offered him, the burning brands I threw at his feet. To judge by his first letters—and his shy behavior when we met again after I had transferred permanently to the Urbs—he was surprised, astonished, embarrassed by the phrases I had lavished on him. "Your Lordship . . . light of our century unique in the world, cannot be content with the works of others, none being match or equal to yourself." Did he think I referred to his pitiful attempts at drawing for which he had more love than talent? . . . "And if I do not possess the skill of sailing on the surging sea of your valorous genius . . ."

I was mad. Mad with his beauty. All those babblings of a love-deranged man he listened to, that boy, with superb grace despite his obvious embarrassment. It was obvious that he looked upon me as a deity that had unaccountably swum into his ken. He was honored beyond his merits. Whereas I wanted only to be the sole of his boot that he might tread on me all day. I was enthralled to an armed knight, and he didn't even know it. I had him pose for some of the figures of my altar and even then he didn't know for I poured all my desire into those images on the holy wall. No voices could ever attribute to me those unmentionable vices attributed to Master Leonardo and his circle. To my young friend I was a Socrates whose nagging Xanthippe was his art and from whose side they rose as untarnished as when they had laid them down to sleep, as Ascanio wrote with such charming indignation in his biography of me ten years ago.

But I was a Socrates with gritted teeth; I felt always eyes gazing down at me from the Cross. His eyes, my father's, my own. The Crucified crucifies me, I am devoured by self-judgement.

Burning burning, then, like Sant'Agostino I would run from Cavalieri to Colonna, from the sun to the shade, freezing in the flames and burning in the shadows, riding by night while others slept, frozen and flowing like a frieze of Attic horsemen. In the Marchesa's circle I talked vaguely of redemption for a sin I had never committed and was never to commit. There were devils stirring in my phantasy; and from those deep underground cisterns they emerged, sometimes to lodge in the depths of my private Hell, leering in all their hideousness; sometimes, transformed, they have risen into the upper right heaven of my Judgement where the redeemed dead embrace again, and among those kissing each other on the mouths are many Michelangiolo's and many Tommaso de' Cavalieri's.

I think the Magister might have been aware of those illicit embracements when he complained to the Holy Father about the nudities of my vault. Poor Monsignor Biagio! The awful revenge I took upon him! As I had revenged myself against Julius, relating the acorns of his escutcheon to the genitals of my Ignudi.

Young Cavalieri I had met through a Florentine sculptor in the service of the Cardinal Ridolfi about whom gravitated so many of our Florentine exiles. He was introduced to me as a young man enamored of art, and with no uncommon attainments. Later, when I could judge with clearer eyes I realized that Tommaso's talents were very small indeed, but thirty years ago I saw everything through a heat-haze which enlarged his merits enormously as when one sees the full moon rising at Arcetri through an August fog.

Shortly after our first meeting I had to return to Fiorenza. I was shuttling back and forth those days between the Lily on the Arno and the Orchid on the Tiber, between murderous Duke Alessandro and vacillating Pope Clement, between my obligations to complete the Medici tombs and my hopes to resume the greater and never-to-be-accomplished tomb of Pope Julius. But now the meeting with Cavalieri filled me with a renewed desire to spend as much time as possible in the Holy City. I seized upon every excuse to absent myself from my own ungrateful nest, my cloying clinging brothers, who looked upon me only as a purse to dip into; the ever-threatening menace of that Moor Alessandro who insisted that I build him a fortress which I had no intention of building. I had every good reason to run off to Roma as often as possible, and soon I had resolved that at the first possible opportunity I would transfer there never to return.

And every time I came to Roma there was Cavalieri, lolling with careless ease, one hand on hip, fencing off my effusive compliments with skillful and courteous self-effacement. Certainly in the balance of the years I see that his self-disparagement was closer to the truth than my effulgent rhetoric. The boy had some ambitions in the arts and showed me his drawings, poor things really, pathetic scribblings, as clumsily drawn as he in his person was all grace; and lying shamelessly I told him that his genius was beyond compare, that he was 'unique' (he was indeed but not as an artist), that I was 'overwhelmed' etc. etc. I suppose there was some irony in this for I felt ashamed of myself, addressing a simple youth in terms which I have never used even with the six Popes I have worked for, or the Sultan when I refused his offer, or King Francis when he begged me to enter his service.

Yet I was not alone in my love for Tommaso de' Cavalieri. Everybody loved him. Even that shrewd and un-giving Holy Father. And the Cardinal Ippolito de' Medici. And Messer Bartolommeo Angelini, my banker. When the Cardinal saw the drawings I had made for Tomao, he wanted the Tityos and Ganymede done in crystal. No, I was not alone in my friendship, a friendship fervid as any love— many of the most celebrated wits of Roma rotated about this young man. His amazing luminous dark eyes, his beautifully-hewn nose, his lips carved and

glistening like rolling breakers, his lithe and graceful carriage, his melodious voice,—everyone in Roma celebrated the beauty of Messer Tomao; he seemed to many—in that neo-Hellenic atmosphere of Paul's Roma, a Roma that now seems as far away as the Roma of Nero, that Roma that was burnt in the fires of Caraffa— in that perfervid pre-trentine Roma Tommaso de' Cavalieri seemed the embodi- ment of a Greek—not Christian—god. Or perhaps I had better say, now that I am old and know better, Christian *because* Greek. We worshipped at the shrine of beauty. The Beautiful was the True. Had not Christ manifested Himself in the form of a young man? What then was more holy than the form of a young man? Some of my friends have seen my Tommaso's face in the Christ of the Judgement. If so, he crept onto that wall imperceptibly as his image flowed through my eyes to my heart. La man ubbidisce . . . yes, but not entirely. Images have often appeared, especially in my painting, which arose I know not wherefrom—faces seen in dreams, limbs sprawled and strained and bodies stretched in ecstacies—night- mares. So it is quite possible that my Christ is Tommaso. Sebastiano used to say so. I don't see it. I meant no blasphemy. I abhor portraits anyway, although I did relent under the hammering of my love to do a portrait drawing of messer Tommaso which made the rounds of all his friends and caused some murmuration, since my distaste for portraiture was well known. It was said that even Raffaello could have done better. I am sure.

So we all loved Cavalieri and there was nothing carnal in our love although it resided in and was inseparable from the beauty of his flesh. The Mystery was there—the mystery of a gesture, a flung shrug, a toss of the head, a hand straightening a vagrant lock of hair. He had a curious way of tucking in the dagger at his belt, a twitch of the shoulder, a hunching of his loins. He lounged a lot and yet seemed all elastic readiness to spring into action. I loved the play of his scapula through the thin jerkin, the swell of his thighs when he walked. He rarely said anything of great moment, but who cared?—the play of expression on his finely chiseled face said everything as the surface of a pond speaks when the wind plays upon it. So Tomao's face was now placid, now perturbed, his frowns added a fascinating play of lines upon the ivory brow, his astonishing eyes now deepblack as Tuscan wells, now dawning with enlightenment as I explained some secret of my craft to him. He loved my art, deeply, passionately, he treasured my drawings as if he had received leaves from the Cumaean Sibyl, he showed them to everybody— Popes and Cardinals—although there was never a Christian drawing among them; and he had the courtesy to say that the love I bore him was due to the fact that as one excellent in art I was forced to love anyone who followed the same path and loved it, even one born only yesterday as was himself and as ignorant as it was possible to be. Messer Tommaso, in fact, was born when I was creating my Adam of the Sistine vault (God creating Adam but I created God.) And miraculously he did look somewhat like my Adam—a smallish but perfectly formed head, reddish

brown hair, and a magnificent body, a lolling athletic grace. And now that I think on it I did create Tommaso as I had created Adam. Every lover creates his belovèd. The living being is merely the stone out of which we carve our ideal, the clay we model, the paint we fashion with figures who are alive because we birthed them. Who or what the real Tommaso de' Cavalieri was like in 1532 I cannot say. Not even now when I do know the present Cavalieri, the true Cavalieri if you will, my faithful friend of three decades, the elderly gentleman who visits me almost every day, attended by his groom or his son the lutenist and singer, always riding a fine Arab stallion—oh yes I know who *this*Tomao is. But the Tomao I first met in Roma I cannot say existed in life, in reality. He was born of my need responding to his form. I created him as I had created Adam, and I trembled when I learned he had been born that very year I was painting my Adam—1510—twenty-two years before we ever met in Roma.

It seemed a premonition.

So when Cavalieri said he was born yesterday and was as ignorant as can be, his modest abnegations were closer to the mark than my febrile flatteries. These references to my "transcendant genius" etc. and his "ignorance," he bespoke in letters and in voice, and always with a shy smile that had no cunning in it; he was entirely sincere; more sincere I now realize than I was. For how can one be sincere when one is at the mercy of a force beyond oneself? Everyone in my circle of friends—Fra Sebastiano, Luigi del Riccio, the Cardinal Ridolfi, Giannotti, Angiolini—they all knew how much I was enslaved to this young Roman nobleman and they even helped to bear messages between us and my stammering rough-blocked poems addressed to Cavalieri were passed around as if they were public letters like the rimes attached to the hulk of Pasquino on the Corso. But no one laughed at my poems; they read them; they commented on them; and if I needed some work with the file in smoothing away some clumsiness in the word-carving there was always a letteratus like messer Donato Giannotti or later Luigi to help me improve—I dare not say perfect myself—in a craft which was never mine.

But only one of my friends never entered into this world. I mean of course the great Marchesa. Oh yes, now and again, she must have met Tommaso when he accompanied me to those weekly meetings at San Sebastiano. He never stayed. A swift but deep bow, a flourish of his feathered cap, a polite murmured meaninglessness—and he was gone. The Marchesa I am sure never even knew he had been there. She was as impervious to Cavalieri's beauty as he was to her nobility of spirit. There was no commerce between them. His world was art; her's God. And I, poor fool, dwelt in both. I have always dwelt in multiple worlds. Which is why I have been stretched all my life on many racks, torn by simultaneous contrarities, drawn north by Yes and south by No, wanted and not wanted, wanted what I did not want, loved that which I despised, believed in that which I knew did not exist, glorified the Body which is a vessel of sin and besmirched the Body which is an

Instrument of Salvation, the Body He took upon Himself which is my Body. I am a battlefield; my soul bleeds with thousands of carrion who are never dead for within me the battle has not ever ceased . . .

The Marchesa's world was God. But at those weekly gatherings we talked less about God than about the sorry state of his Church. It was a bad time for the Church. It always is. But at that time, before the Council, there was still some hope for reconciliation with the Lutheran heretics, still some belief that the schism in the Church might be healed, still some lurking irrational faith that the worst abuses of the clergy might be corrected, that some real reforms might be instituted in the head and members of the one true holy catholic church. And precisely because there was still this hope, this faith, this stubborn belief that matters might be changed—just for this reason does it seem to me, looking back now down the long corridor of the years, that the situation was worse then than now. For now we know that the schism will never be healed, it is like a wound that runs blood and pus no matter what the valiant surgeons do; we know that certain abuses of the clergy are within the nature of the clergy and no tinkering with the institution of the church will reform them; and that although the Council of Trent may have decided for all time what kind of images may be permitted and how many lines of melody may interweave in Maestro Palestrina's madrigals and masses; and especially since Papa Caraffa's enthusiastic revival of the Holy Office of the Inquisition and the Index, we now know which books are to be burnt (so as to spare the gullible from a more terrible burning) and which may be read in comfortable sanctity—I say, now there is a relative calm in the world, men's minds are at rest because they need no longer use their minds. But in the early days of Paul the Third there was still hope—and that made things bad. Now all is settled once and for all, set down, carved forever in the granitic decisions of the Council of Trent. Hopelessness is a much more comfortable state than hope.

But in those days we thought—some of us—that no Council, not even the Council Paul was cagily preparing, seeking to placate Emperor and King in terms of the place wherein the Council was to be held, hoping even that the Protestants would attend,—could resolve the Mystery of Salvation by the Blood of Christ alone. I have never been able to reconcile Mysteries and Councils; and so rather than to set the world gnarling at my heels I meditate on one in my chambers and practice the other in public.

We should have been aware even then, that with all of Paul's zeal for reform, the commission of liberal cardinals (many of them the Marchesa's friends) he had appointed to prepare for the council, his, the Holy Father's own behavior hardly set an example for a general reform of the clergy. Appointing his grandsons Alessandro and Ranuccio Cardinals at the age of fourteen! Creating 72 princes of the church at one blow, many of them kin close or far of the House of Farnese. Appointing his pederastic son Pier Luigi as Gonfalonier of the Church! The Church needed reform, yes, the Holy Father was cautiously calling for reform. It

was the only way to halt the spread of the Lutheran heresy. But Paul too needed reform; his own hands—so busily weaving webs, nets, councils—needed cleaning.

But none of this—either the virtues or the vices of the Holy Father—ever escaped the lips of the Marchesa Vittoria. All her talk was situated in so ethereal a realm, so pure were her utterances, so exalted her ideas, so removed from the ruck and moil of everyday life, even the life of the convent wherein she lived as a lay religious, that in her presence all my self-doubts fell away and I felt exalted as I did in the presence of messer Tomao. One exalted me through the beauty of his person, the other through the beauty of her soul; and in both I fled myself and found myself.

She was as plain as Tommaso was dazzling. Her hair lank and tightly gathered into a knot. Her eyes were small, a vague hazel not unlike my own but with less of the gray and gold glints in them; her mouth generous, smiling often, and a voice that was an instrument of great flexibility and suavity, the rich Roman sonorities of her ancient house of Colonna, an occasional insinuating darting sibilance like the flash of a sword. Her conversation was as dazzling as her aspect was plain. She dressed severely, for the most part in the Spanish fashion, much black; I suppose this was out of memory to her late husband D'Avalos.

Life is indeed an oddness. Here I am now tottering at the grave edge of ninety, carving a Christ skeletal as myself and the night is black black as the ravens for which this street is named, one cannot even see through the February fog, the spectral column of Trajan which has kept me company these many nights when I cannot sleep and come to this studio in the shank of the night, a lighted candle on my cap and tchppp tchppp tchppp away at this statue of the Divine Mother and her Divine Son which is no statue at all but a stubborn column of Parian marble which I salvaged from the baths of Caracalla and from which I have been vainly for ten years seeking to extract a Christ that is no Christ, a Maria that is no Maria, a pure Idea that lodges somewhere at the back of this ancient skull of mine, this hive of memories, this resounding chamber which contains in itelf more echoes than the great round church of the Angels which I extracated from a Roman bath as I cannot seem to extract these Forms from this Roman column and the Marchesa's bones are whiter now than this marble dust and yet here in this lonely studio— silent at last from the daylong howling of my whorish maids and foolish hands—I seem to see her again clear as life, clearer than this Pietà, which eludes me. She seems to rise again right out of her tomb and I hear her laugh as so often she did, heartily, like a man, even in the midst of the most pious conversations (and most of them were pious) in that quiet and lovely chapel of San Silvestro on Monte Cavallo. My studio was not far distant, at the foot of that hill, and frequently as I walked to the Thermae, sometimes alone, sometimes in company with Urbino, my Judgement always on my mind (a bloody sunset over the Tiber) for I was laying in the work now day after day, inventing new forms in the wet plaster, sweeping beyond the stylus-lines of my cartoons, even ignoring the cartoons entirely

(especially in the upper right half where there is a free swirl of naked bodies and my phantasy had free rein), so brooding along Monte Cavallo, the path bordered with crumbling monuments of antiquity, my thoughts my own even when my man Urbino was with me and I seemed to be attending to his babbling brookrun of artists' gossip, all the more amusing for his Marchegiano accent.

Suddenly we were at the convent and would pay a call on the Marchesa. Or perhaps it might be that a messenger had arrived at my studio that morning inviting me to come that day.

I went voluntarily. She was a great lady, and one was sure to find always in her presence many of the leading figures of the party of reform. In that austere garden, under a pale sky, our talk measured as the procession of slender columns that lined the courtyard, our conversation inanely commented upon by a trickling fountain and occasionally interrupted by the timid incursion of a nun entering the cortile, a birdlike apparition, wimpled under the chin and the vans of the great starched hood fluttering, a sort of blackbird who flew off once she had delivered her message to Vittoria. One would have thought the Marchesa was the Mother Superior of the convent. One day she told me that she had received permission from His Holiness to build a sort of nunnery for ladies at the foot of Monte Cavallo "—by the broken portico where it is said Nero saw Roma burning, so that the wicked footprints of such a man may be trodden out by the more honest, footprints of holy women."

My man Urbino coughed, I thought aggressively.

"The broken portico might be used as a bell tower," I suggested. Later we went together to look at the site and I gave her some drawings for it.

But actually with all her authority there, she was not even a member of the order; she was not a nun, she had never taken any orders at all. But Vittoria Colonna emanated authority as the sun emanates light and warmth. She was a member of the ancient house of the Colonna and even had she not been the widow of his lieutenant, Ferrante d'Avalos of Pescara, the Emperor Charles would probably have paid obeisance to her.

There was much talk about the blood of Christ in Vittoria's circle. And listening to these subtle divines—listening for the most part in silence, for although in my youth I was given to disputation, especially theological (those analogical arguments with Andrea the Jew! My Jesuitical—before the Jesuists!— reply to the Cardinal de St. Denys when he questioned the youthfulness of my Madonna), then in my early old age and now beyond age entirely I no longer care to dispute holy issues. I quarrel only about my art. I quarrel with the overseers of new St. Peter's abuilding. But I do not quarrel with those same overseers when as priests they pretend to set my soul aright. I am beyond such quarrels. I commune directly with Him on the Cross.

And now that I think back on it, that was what Vittoria and her circle were seeking to do. The Oratory of Divine Love they called themselves and they